RA · ALBA FLORA · ALCHERMES · ALE · B. ALE · ALICANTE · ALICANT · ALIZE · ALMADE · ALMEID▪
ELIQUE · ANGOSTURA · ANGOSTURA BITTERS · ANISETTE · ANNISCETTE · ANNISEED · AN▪
ISER · ASSMANSHANSER · ASTI · ATHALIE · AULD KIRK · THE OLD KIRK · AUSTRALIAN CLARE▪
▪OLAIS · BEAUNE · BEAUME · BEER · BEER MUG · BEESWING · BEESWING PORT · BÉNÉ · BENED▪
▪DDER · BLACKBERRY BRANDY · BLACK CURRANT · B.MADEIRA · BN CURRENT · BOAL · BUAL · B▪
· BOURBON · BOURGOGNE · BOURGOGNE MULSEAUX · BOURGOGNE VOLNAY · BOURGONE · B▪
▪NDY SHRUB · BRESCIA · BRITISH · BRITTEN · BRONTE · BRONTÉ · BRONTI · DUCHY OF BRONTE ·
▪S BUCILLAS · BURCELLAS · BURCELLOS · BUSELLAS · BORCELLAS · BUCHANANS ROYAL · H▪
▪MBY · BUSHMILLS · BYRRH · C.DE.ROSE · C.A. · C.B. · CACAO · CAHORS · CALABRE · CALAMIT▪
▪AVELLO · CARCAVELLOS · CARCAVALLA · CARCAVALLA · CARCOVELLOS · CARCOVELLO · CA▪
· CANARIAS SECO · CANARIE · CANARY SACH · CANNELLA · CAORE · CAP · CAP BLANC · DE CA▪
▪N CAPILLAIRE · CAPILARE · CAPRI · CAPTAIN WHITE'S · CAPT.MASTER R.M. · CARCAVELLA · C▪
▪ CHAMBERY · CHAMBERTIN · CHANBOLLE · CHAMPAGNE · CHAMPAGN · CHAMPAGNER · CHA▪ CHAMPAIN · CHAMPAINE · CHA▪
▪GNE · RED CHAMPAGNE · R.CHAMPAGNE · SPARKLING CHAMPAGNE · CHAMPAGNE ROUGE · R.CHAMPAIGN · RED CHAMPA^N · SWT.CHAMPAGNE
▪ GELDER CHARTREUSE · GREEN CHARTREUSE · CHATEAU · CHERAC · CHERES · CHERESSE · CHERRY · CHERRY BRANDY · CHERRY B^Y · C.BRANDY
▪RY WHISKEY · CHETNA · CHIANTI · CHICHES · CHINA · CHUSCLAN · CHUZELAN · SCHUSELAN · SCHUSELANE · CHYPRE · CHIPRE · CIDER · CYDER
▪DINNER · CLARET · BEST CLARET · DINNER CLARET · F.CLART · LIGHT CLARET · OLD CLARET · PREMIER CLARET · CLARET 2 · CLARET 66 · NO 1 CLARET
▪LAIRRET · CLARY · CLOS VEUGEOT · CLYNELISH · COCKAGEE · COCKTAIL · COCNAC · COGNAC · COGNAC 1840 · COGNIAC · CONIAC · CONJACH · EAU
▪RES · COLARES · LISBON COLLARES · COLOGNE · COLTSFOOT · COMO · COMMANDARIA · COMMANDER · CONDRIEUX · CONSTANCE · CONSTANTIA
▪ CONVENT · COOKING BRANDY · COOKING SHERRY · COPENHAGEN CHERRY BRANDY · CORACAO · CORDIAL GIN · CORNAS · CORIN · CORREMILLA
▪OTIE · COULANGES · COUNTRY · COWSLIP · CRÈMA DIVINO · CREMA DI VINO · CREME D'ALLASCH · CREME DE CAÇAO · CRÈME DE MENTHE · C de M
▪ETTES · CREOLE · CURAÇOA · CURACOA · CURAÇAO · CURROSOS · CURACAO BLANC · CUROCOA · CURASCOA · WHITE CURACOA · GREEN CURAÇOA
▪CURR^T.WHISKEY · CY.BRANDY · CYLIN · CYPRUS · CYPRESS · C.WHISKEY · CYSER · DALMATIA · DAMASCENE · DAMSON · DAMSON GIN · DANSKT · DANTZIC
▪SHERRY · D'OEIL DE PERDRIX · D'MADRAS · D.O.M. · D'ORGEAT · DONALD · DRAAGENSTEIN · DRY · DRY CHAMPAGNE · DRY FLY SHERRY · DRY GINGER
▪ERRY · EAU DE DANZIG · EAU DE LUBIN · EAU DE MIEL · EAU DE VIE · EAU DE VIE D'ANDAYE · EAU DE VIE FROM FRANCE · EAU DE VIE DE COGNAC · EAU
▪SH CLARET · ENGLISH GIN · ENGLISH WINE · ENNISHOWEN · INNISHOWEN · ERLAURE · ESCUBANCY · ESCUBACY · ESPAVAN · ESPAGNE · ESPANAU
▪ARET · F.C. SHERRY · FACEL · FAHLU · FALERNIAN · FALERNO · FALU · FARO · FERNET BRANCA · FINE CHAMPAGNE · FIN CHAMPAGNE · F.CHAMPAGNE
▪LE · FRAISETTE · FRENCH CLARET · FRENCH VERMOUTH · F.V. · FR.VERMOUTH · FR.WHITE · FR.WINE · FR.W-WINE · FRENCH W-WINE · FRENCH WHITE
▪ FRONTANIAC · FRONTANIAC · FRONTINEAC · FRONTINIAK · FOUNTINIAC · FOUNTANYOCK · FONTONIAC · FRONTIGUAN · FRONTINIACK
▪CCHIO · GENEROIDE · VIEUX · GENEVA · GENEBRA · GENEVER · GENEVRE · H.GENEVA · GENEVER FROM HOLLAND · GENEIVER · GENIEVRE · GINEVA
▪ GINGER SHRUB · GINGER WINE · GINGERETTE · GINGERHAM · GI ROM · GISCOURS · GLENDRONACH · GLEN DRONACH · GLEN · GLENLIVET · GLORIA
▪RAIN · GRANACHA · GRANDE MAISON · GRAND MARNIER · GRANDE · MARNIER · G.MARNIER · GRANDE MANIER · GRAPE · GREEN GRAPE · GRAPPA · GRAPPE
▪ALLOW'EEN · HAMMAN BOUQUET · HAMMICKS MORILES NO 5 · HAMMICKS MORILES NO 7 · HAMMICKS MOLITES NO 7 · HAU BRION · HAY · HEAVY
▪M^T · WH.HERMITAGE · HARMITAGE · H.GENEVA · H.GIN · HEYWARD · HIGHLAND WHISKY · HIGHLAND · HIGHLAND · LIQUEUR · HINOJO · HIPPOCRAS
▪LLANDS · HOLLAND · HOLL^DS GINN · HOME-MADE · HOME · HUILLE · HUILLE DE VENUS · HUNGAR▪ · HONGRIE · HUNGARIAN · IDEAL · IMPERIAL
▪IRISH SETTER · IRISH W · IRISH WHISKEY · IRISH WHISKY · I.WHISKEY · I.WHISKY · I.W. · ISCHIA · ISLAY · ISLAY MALT WHISKY · IT ITALIAN · ITALIAN VERMOUTH · IT
▪ANESBERG · JOHANNISBERG · JUNIPER · JURANCON · JURANSON · JURANSON BLANC · J.W.DENNISTOUN · KEFFESIA · KERES · KHOOSH
▪ER · KIRCHWASSER · KIRSCH A WASSER · KIRSCHENWASSER · KUMMEL · KUMMEL · KURAMEL · KÜMMEL · KIMEL · KIMMEL · KUEMMELL
▪HRISTI · LACHRYMA AE CHRISTI · LACHRYMA · LACHRYMAE · LACKRYMA · LACRIMA · LAFITE · LAFITTE · LA FITTE · LAFFITTE · CHATEAU LAFITTE
▪ LANGON · LANGUEDOC ROUGE · DE LANGUEDOC · LANQUEFOC ROUGE · LA ROSE · LAROSE · CHATEAU LAROSE · LATOYR · LAVRADIO · LILLET
▪LILLET · LIQUEUR BRANDY · BALFOUR'S LIQUEUR BRANDY · LIQER BRANDY · LIQUEUR · LIQUER · LIQUERE · LIQUOR · LICQUER · LIQUEUR de BIRSE
▪LUNEILLE · LUTOMER · MACABER · MACABOR · MACON · MADEIRA · MADEIRA · MADERA · MADÈRE · MADERE · MADEIRA · MEDEIRA · MEDEIRA
▪DEIRA · SPANISH MADEIRA · OLD MADEIRA · 484 MADEIRA · MADEWINE · MAHONEY BOY · MAJORCA · RED MAJORCA · WHITE MAJORCA · MALAGA
▪MALVOISEE · MALVOISIE · MALVEZIE · MALMSEY DRY · MALMSEY RICH~ · MALMSY RICH · MALMSEY MADEIRA · MALMSY MADEIRA · MALVOISIE DE
▪MANEATER · MANHATTAN · MANZANILLA · MANZANILLA DRY · MANSANILLA · MANZANILLO · MARACHE · MARASCHINO · MARAS^C · MARASQUINA
▪MARSEILLA · MARCELLAS · MARCLLA · MARSELLA · MARSELLIA · MARCEILLES · MARSEILLA · MARSELLIS · MARCELLE · MARSAILES · MARSELA
▪LLA MARSALLA · MARSCALLA · MARSELA · MARTINI · MASDUE · MASDEU · MASDU · MASDIEU · MASSALA · MASALA · MASSALA · MAZZARA · MEAD
▪Mk.PUNCH · M.PUNCH · MILLBURN · MINT · MINTE · MIRABOLANTE · MISCHIANZA · MISCHANZA · M.MADEIRA · MOLESCOT · MOKA · MONROSE
▪ MONTILLO · MONTPELIER · MONT RACHE · MONT RACHET · MONTRACHET · MORACHE · MORACHEE · MORACHET · MORILES SHERRY · MORAT
▪MOTHERS RUIN · MOUNTAIN · MOUNT · MOUNTIN · MOUNT^N · OLD MOUNTAIN · MOUNTAIN DEW · MOURACHE · MOURACHE ROUGE · MURACHE
▪RE · MURON · MURSEAULT BLANC · MUSCAT · MUSCAT BLANC · MUSCAT DE FRONTIGNAN · MUSCAT DE FRONTIGNE · MUSCAT DE LUNEL
▪CKAR · NECTARINE · NECTOR · NELSON · NEUCHATEL · NEWTONIA · NICE · NEICE · RED NEICE · NIZZA · NIERSTEINER · NIG · NOISET · NORFOLK
▪N.PUNCH · OBERMMEL · OBRION · OBRYON · O.D.V. · O.D.V. DE DANZIC · O.W. · OLD CLARET · OLD HOCK · OLD PORT · OLD RUM · OLD MOUNTAIN
▪ PORTO · OPORT · ORANGE · ORANGE BITTERS · ORANGE BRANDY · O.BRANDY · ORANGE CURACAO · DRY ORANGE CURACAO · ORANGE GIN · ORANGE
▪SSTI · PUCURET · PAQUARETE · PAQUARET · PACKERETTA · PACKERETTE · DRY PACARETTE · PACCARROTTI · PAGARÈS · PAID · PAJARETTE · PAJARETE
▪IIP · PARTNERS · PASS THE BOTTLE · PASTO · PATRAS · PAXARETE · PACARETTE · PAXATETTA · PACERETTE · DRY PAXARETE · PAXARITE · PAXAROTTA
▪I-CHINNES · PERALTA · PERALTE · PÉRE KERMAN · PERPIGNAN · PERRY · PIERRY · PERSICOA · PERSICO · PICCOLIT DE L'ANNEE · PICARDON · PICO
▪QUALITE' · PONTAX 2,DE QUALITE' · PONTE · PONTET CANET · POPT · PORT · PORT À PORT · PORT 1840 · DRY PORT · LIGHT PORT · L.PORT · PORT VIIN
▪RT A.L. · PORTWYN · PORTVIN · ROBERTSON'S PORT · SANDEMAN'S PORT · PORT VEIN · SWEET PORT · VINTAGE PORT · W.PORT · WHITE PORT
▪PORTWYN PORTVIN · POTURON · PREMIER CLARET · PREMIER HOCK · PRIEST · PRINIAC · PRENIAC · PREIGNAC · PREIGNAT · PRIGNAC · PREGNAC
▪QUINTA DE PONTE · RACK · RAISIN · RAISEN · RAISIN WINE · RAISIN WINE · REASIN · RALPH JAMES & ROBERT · RANAS · RANCIO
▪ RATAFIE · RATAFIA DE DANTZIC · RATAFIA DE DANZIG · RATAFIA DE CERISES · RATAFIAT DE FLEUR · D'ORANGE · RATIFIE · RATFFIA · RATZERSDORF
▪HAMPAN · RED CONTANTIA & RED · CONSTANTIA · RED HERMITAGE · RED HOCK · RED MADEIRA · RED MAJORCA · RED NEICE · RED NOYAU · RED PORT
▪ RENISH · RHIN · REIN · RHINSKIVIIN · RHONE · RHUM · RIN · RHUM BICARDI · RIN WINE · RIOJA CLARET · RIO TORTO 1820 · RIVERHEAD · RIVESALTE
▪OUSILLON · ROUSSILLION · LORD ROUSSILLON · ROQUEMAURE · ROYAL · R.S. · RUDESHEIM · RUDESHEIMER · RUM · OLD RUM · RUM SHRUB · RUSTER
▪ SACK MEAD · SADES · ST.ELIE · ST.EMELION · ST.ESTEPHE · SAINT GEORGE · S.^T GEORGE · ST.GEORGES · ST.GEORGE · ST.JOSEPH · ST. JULIEN · S.^T
▪CTA · SANDEMAN'S PORT · SAN LORANO · SANTO · SANTO BIANCO · SANTO-NERO · SANTORIA · SANTORNEI · SANTENAY · SANTO VIN · SATUERNE
▪VA · FROM HOLLAND · SCHEEDAM GENEVA · SCHERRY · SCHIEDAM · SCHIRAZ · SCUBAC · SCHUSELAN · SCHUSELANE · SCOPOLI · SCOTCH · SCOTCH
▪RA · CERCIAL MADEIRA · SETGES · SAYES · SCYES · SEYES · SICHES · SICILE · SIEGES · SETJUS · SIETGES · SITGES · SITZES · SETUBAL DE PORTUGAL
▪IP · E.I.SHERRY · F.C.SHERRY · GOLD SHERRY · GOLDEN SHERRY · MORILES SHERRY · HAMMICKS MORILES NO.5 · HAMMICKS MORILES NO.7 · HAMMICKS
▪2 SHERRY · DESSERT SHERRY · B.CREAM · A.SHERRY · BITTER SHERRY · SHERRY BRANDY · SHERRY SACK · SHERRY MORO · SHRUB · R.SHRUB · C.SHRUB
▪ SLOE WINE · SMYRNA · SMYRNA WINE · SOLERA · SOLFERINO · SOUMUR · SOUTHERN · SOUTERN · SPANISH · SPANISH WINE · SPANISH MADEIRA
▪TIN · TARRAGONA · MR TARRATTE · T'AVEL · TAWNY PORT · TENERIFFE · TENERIFF · TENERIEFF · TENERIEFE · TENERIFFE · TENNERIFFE · TENERIFFE
▪TINTA MADEIRA · TERMO · TERMEAU · TURMEAU · TOURNEAU · THE ABBOTS BOTTLE · THE ANTIQUARY · THE DUKE 1812 · THE OLD · THERA · THISTLE
▪KAY · TOKEY · TOQUAY · DE TOKAY · TONNERT · TONNERE · TORINO · TORRIN · TOURIGA · TOURS · TRAPPISTINE · TRIA JUNCTA IN UNO · TRIPLE SEC
▪PENAS · VALPOLICELLA · VANDEGRAVE · VAN DE PURLL · VAN DER HORN · VANDUHUN · VELHEDRO · VERDELHO · VERDAGLIO · VERGUN · VERGUS
▪DONIA · WIDONIA · VYDONIA · VIEUX COGNAC · VIENNE VERGUS · VIEUX MARC · VIN · VINAM · VIN D'ALOQUE · VIN DE BEANNE ROUGE VIN DE C▪
▪S · VIN DE GRAVE · VIN DE FREVE · VINE DE GRAVE · V.DE-GRAVE · VENDEGRAVE · VIN DI GRAVE · VIN DE GREVO · VIN,DE,LA BLONDE · VIN DE LUNELLE
▪HIN · VIN DE SCOPOLO · VIN DE TAVEL · VIN DE TOKAI · VIN DE VIERGE · VIN ORDINAIRE · VIN DE PASTO · VIN DE PASTO · VIN · DE PAYS · VIN DI
▪RA · VOLNAY · VOLUAIJ · VOSNE · VYDOINA · W.HERMITAGE · W.PORT · WALPORZEHIM · WEBBER · WHISKEY · WHISKY · SHYSKY · VHISKEY · WELSH
▪KY · WHITE WHISKEY · WHKSE · WHITE · WIGHT · WHITE BORDEAUX · WHITE BURGUNDY · WT.BURGUNDY · WHITE CAPE · WHITE CONSTANTIA
▪ W.HERM^T · WHITE LISBON · WHITE MAJORCA · WHITE PORT · WHITE PORT WINE · W.PORT · WHITE PORT WINE · W.PORT · W^E PORT · WHITE WHISKEY
▪QUEM · CHATEAU Y'QUEM · ANGELICA CHATEAU Y'QUEM · C.YQUEM · YGNEM · YVORNE · YVOINE · YAP · ZANTERA · ZERRY · "Zq" · ZELTINGEN

Bottle Tickets

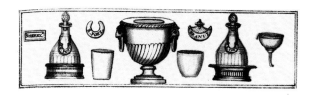

Jane Stancliffe

VICTORIA
& ALBERT
MUSEUM

Acknowledgements

I am grateful to the Wine Label Circle for permission to reproduce as endpapers their list of wines recorded on bottle tickets. Illustrations for the introduction have been provided by the Worshipful Company of Goldsmiths, Guildhall, The Ashmolean Museum, Manchester Art Gallery, The Museum of London, Sir John Soane's Museum, The Metropolitan Museum of Art, Sotheby's and Sheffield Reference Library: my thanks are also due for help generously given on this publication to Shirley Bury, Judith Banister (pl 22), Captain Sir Thomas Barlow (pl 22), Michael Parkington (pls 6, 19, 20, 22, 39, 62), John Culme, Elaine Barr, Anthony Berry and Patrick Gaskell Taylor.

Designed by Aitken Blakeley
Photography by Geoffrey Shakerley
Edited by Philippa Glanville
Printed and bound in the Netherlands
by Drukkerij de Lange/van Leer BV

ISBN 0-905209-90-7

Contents

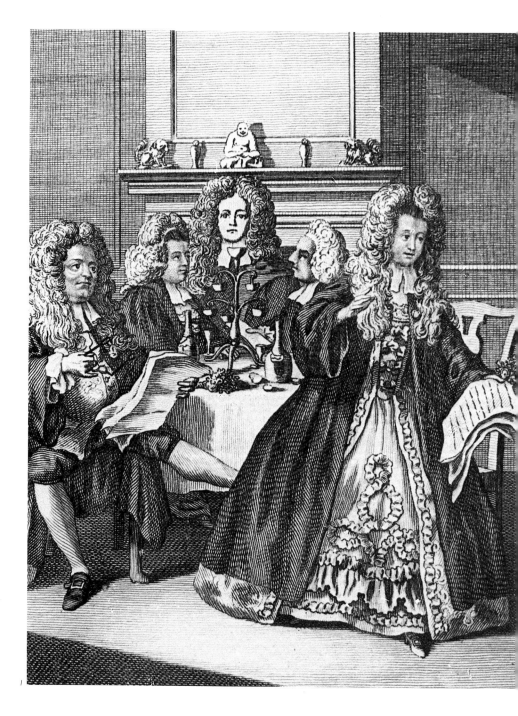

Introduction

We have all seen or heard of the wine or decanter label, so popular with collectors, and for some it may therefore appear misleading to entitle this book 'Bottle Tickets'. However, for much of the eighteenth century, when they first appeared, wine and decanter labels were known as bottle tickets. An early reference to a bottle ticket occurs in the Gentlemen's (Clients') ledgers of the fashionable goldsmith George Wickes, when on 9 May, 1736/7, Lord Lymington was charged £1.10d for 'six Bottle Ticketts'.

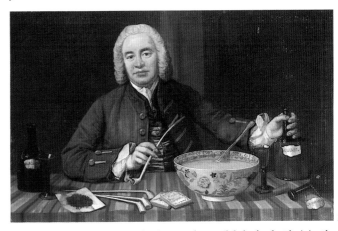

2

Contemporary gazettes begin to refer to 'labels for bottles' in the 1770s but not until the 1790s were they established as wine or decanter labels. Their function was to identify the contents of a bottle or decanter, which might alternatively contain spirits, sauces, toilet waters or cordials; all these types are described and illustrated in this brief survey. The bottle tickets in the Victoria and Albert Museum number some seventeen hundred, the greater part of the collection left by the late Mr PJ Cropper in 1944.

The history of bottle tickets provides a fascinating insight into English eating, drinking and personal habits. Tickets also illustrate in miniature the skills of the silversmith over the last two hundred years. An advertisement in 'The Public Advertiser', on 29 May, 1765, underlines the importance owners attached to their possessions, even the comparatively insignificant bottle ticket: 'Stolen, 5 silver scalloped Bottle Tickets entitled Claret, Hock, Burgundy, Madeira and Port'. In their heyday they were fashion's favourites and a status symbol; Maria

1
From Town and Country Magazine Vol. II p.361, July 1770
2
A Gentleman smoking his pipe and taking wine, c.1745. Attributed to Stephen Slaughter (Sotheby's)

Edgeworth's novel, 'Belinda' (1801) included an amusing reference to wine labels: '. . . the two Lady R's . . . like two decanters in a bottle coaster with such magnificent diamond labels round their necks'.

While the variety of styles and materials used was enormous, silver bottle tickets tended to reflect fashionable designs in metalware generally. Makers were quick to adopt the many technical advances of the eighteenth and nineteenth centuries.

Origins

Bottle tickets were peculiarly English; they never became fashionable abroad although they were made in limited quantities during the nineteenth century in Europe and elsewhere, often under the influence of expatriate communities. For example, Indian craftsmen mounted boar's

tusks and tiger's claws (pl 3) in engraved or filigree silver, in China they were wrought as dragons, and labels in the form of Burmese figures are known. Examples from Sweden and Holland were not uncommon and some fine examples were made in France, in the early nineteenth century. Elsewhere silversmiths in Canada, Australia, North America, even Russia copied English designs and developed their own styles for local demand.

The beginnings of the bottle ticket can be traced back to the early seventeenth century. At this time the choice of imported wines was limited; they were brought to table in tin-glazed earthenware bottles made at kilns along the Thames in Southwark and Lambeth. These pottery bottles popular between about 1630 and 1670, sometimes had the name of the wine, and a date, incorporated in the design (pl 4) and replaced the stoneware bottles formerly imported from the Rhineland for table use.

At about the same time the first English

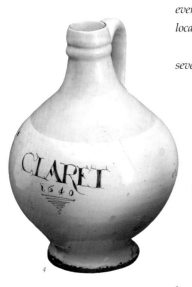

glass-bottle makers set up in business. The advantages of glass soon became apparent; it was cheaper than stoneware and the use of cork stoppers made it possible to mature wine in glass containers. As early as 1620 bottles are recorded as having glass seals bearing the armorials of private individuals, and the date of making or device of a tavern, but there is no evidence of names of wines appearing on these seals. It was soon realised that the beauty of the natural colour of wine was hidden by

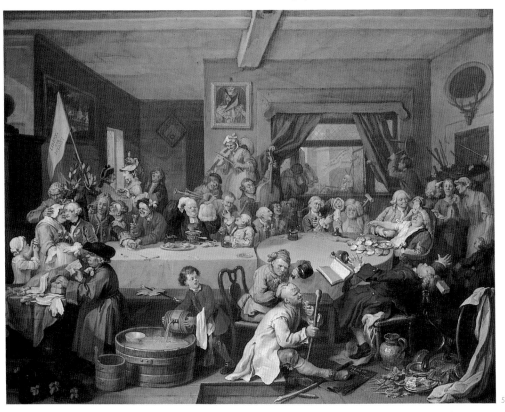

5

the almost opaque thick glass, making it difficult to distinguish one wine from another. Thus from the late seventeenth century before the bottle was brought to the table, a ticket had to be added, tied by string to the bottle neck. The earliest were merely written on pieces of parchment (as on the bottles in pl 5), leather or painted wood.

An increase in the import of wines (pl 7) towards the end of the seventeenth century started a new fashion for laying down and enjoying

7

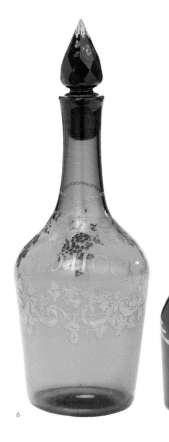

6

good wine. As early as 1663 Samuel Pepys mentions in his Diary on 19 January '. . . but still above all things he [Mr. Povey] bid me go down into his wine cellar, where upon several shelves there stood all sorts of wine, new and old, with labells pasted upon each bottle and in that order and plenty as I never saw books in a booksellers shop'. The Methuen Treaty in 1703 stimulated the import of many new wines, in particular from Portugal. The English did not take to their rather coarse wines immediately and Jonathan Swift wrote in 'Letters to Stella' (1712) 'I love white Portuguese wine better than Claret, Champagne or Burgunday; I have a sad vulgar appetite'.

Glass decanters appeared as early as the 1670s; it gradually became apparent that the clumsy parchment labels would have to be replaced with something more in keeping with the elegance and artistry of the clear flint glass, popular by the early eighteenth century. While silver bottle tickets slowly gained favour from the 1730s, glass cutters, engravers and enamellers experimented with alternative solutions to the problems of labelling. In the 1760s for instance, white enamelled glass decanters made by the Beilby's of Newcastle had the name of the wine incorporated amongst butterflies, vines and floral decoration. At about the same time glass decanters, engraved with panels containing the names of their contents with wheel-engraved mantlings above and vine leaves and grapes below, had earned the recognised trade name of 'label decanters' in contemporary gazettes. The manufacturers of dark blue and green Bristol glass extended the fashion with the representation of the label, delicately executed in oil gilt, bearing the name of the wine held by a chain round the neck of the decanter or soy bottle (pl 6). Examples in clear and coloured glass with elegant rococo designs in gilt also came from the London workshops of James Giles (pl 6).

Function

The latter part of the seventeenth century saw a general refinement of manners among the upper classes, much influenced by the court of Louis XIV. Changes in the serving of food required new forms of tableware. In the higher echelons of society formal dinner, the main meal of the day, took place at 2 or 3 o'clock; the hour gradually becoming later as the century progressed. Footmen attended to individual needs

of guests by taking their plates to the dishes laid out on the central table. Glasses did not remain on the table; instead, the butler stayed at the sideboard with the wine, and the footmen brought the glass to be filled, refilled or rinsed in a cistern of water under the sideboard. Swift's 'Directions to Servants' (1745) gives us an excellent if somewhat satirical idea of correct 'form'. While decanters were not placed on the table during dinner (although they were during an informal gathering as in pl 1), afterwards, when the ladies had withdrawn, the butler laid out the appropriate glasses in front of each guest, and the decanters were placed in front of the master of the house to be passed round. Coasters are thought to have been in popular use by the 1750s; again, until the beginning of the nineteenth century, they would be used only after dinner, when the tablecloth had been removed. They were invented to enable guests to slide decanters or bottles across the table with ease without scratching the surface; they had baize-covered or polished wood bases and later were sometimes on wheels. The wine-bottle stand was an early version of the coaster; examples are extremely rare, and sometimes mistaken today for sugar bowls (pl 8).

By the early nineteenth century it became fashionable for decanters and glasses to remain on the table throughout the meal, and the new service 'à la Russe', well-established by 1830, meant that no food was kept on the table. Dishes were offered by the servants and then immediately removed. The result was that very much more silverware could be put on the table, such as elaborate centrepieces, candelabra and wine coasters (pl 9).

English excess in drinking is discussed in many contemporary

6
Old Hock: glass, English, c.1775, possibly from the workshop of James Giles (Michael Parkington, Esq.); Soy: glass, Bristol, c.1780 C.5353-1901
7
'Vitis Viniculta' from Plante Geographisk Atlas 1824, by E.F. Schouw (Royal Geographical Society)

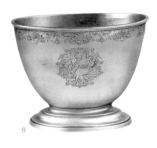

8

diaries, books and novels. In D McCormick's 'The Hell-Fire Club' (1721) we read about the two monks, Thomas de Greys and John of Henley who consumed four bottles of port, two of claret and one of Lisbon at one sitting! Wine was stored in bulk and kept in cavernous cellars in casks and bottles, to be decanted by the butler for daily use. At Harewood, for example, in 1805 there were two thousand bottles of both port and sherry in stock and one thousand each of madeira and calcavella. The cellar book, finely printed on high quality elegant paper, listed the wines which were in regular use.

Dr Johnson tells us that 'The true felicity of life is in a tavern' but this changed in the eighteenth century when the coffee house reached its peak of popularity, being club, bank, newspaper, library, stock exchange all in one. In the coffee house or on informal occasions, unlike the practice at elegant dinner parties in private homes, bottles of wine possibly with tickets remained firmly on the table (pls 1,2,5). In the often raucous and confused atmosphere of the clubs the bottle ticket must have been an essential guide to servants.

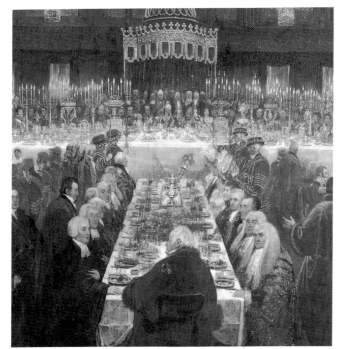

8
Bottle Stand 1723/4, Augustin Courtauld; the arms of Veal impaling Young (Ashmolean Museum, Oxford)
9
'A banquet given for the Emperor of Russia, the King of Prussia and the Prince Regent of England in the Guildhall' 1814 (detail) by George Clint (Guildhall)
10
Ivory, mid-19c. M.1368-1944
11
Cruet frame, silver-gilt with cut-glass cruets. Mark of John Scofield, London hallmark 1789/90. The labels made by Susanna Barker, late 18c. M.46-h-1960

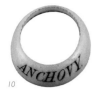

From the earliest times, spicy vinegar-based sauces were essential to make palatable food which had been dried, salted and stored for considerable periods. The variety of sauces in the eighteenth century increased steadily. Sauces were dispensed from the sauce boat, spicy pickles from the long-established saucer, salt from the salt cellar and other condiments (pepper, dry mustard, sugar, oil and vinegar) from the cruet frame; bottles for condiments, contained in cruet frames, date from at least the reign of William and Mary. For some the vogue for French food was as alarming as the replacement of ale by tea. A 'deprav'd Taste of spoiling wholesome Dyet, by costly and parnicious Sauces and absurd mixtures' was the way Robert Campbell, author of the 'London Tradesman' (1747) described it. By the late 1760s everything was disguised by sauces so that nothing appeared in its 'native properties'. It is not surprising to find in the best-selling recipe book of the time, Mrs Hannah Glasse's 'The Art of Cookery' (7th edition, 1760), that there were more than thirty recipes for sauces.

The cruet stayed basically in the same form, combining two oil and vinegar bottles with three silver casters, until about 1760 and then silversmiths progressed to making vinegar decanter frames for the glass bottles, equipped with smaller versions of contemporary wine labels. Labels were also needed for pickle and ginger jars; because they were

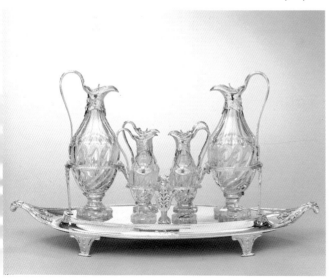

bulbous, the labels had to be bigger and have longer chains. During the same decade the circular soy frame, accommodating anything from five to eleven bottles for essence, became very popular, as it catered for the wide range of flavourings demanded by fashionable French cuisine as well as supplementing spicy pickles.

After the 1770s the cruet frame (pl 11) often included soy bottles, and soy sets were occasionally combined with oil and vinegar sets. Several frames

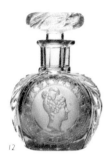

12

were placed on the table at dinner, either at each corner or incorporated into elaborate centrepieces. Contemporary silversmiths' ledgers for the firm of John Parker & Edward Wakelin show that sets of sauce labels were ordered more frequently than sets of wine labels. This was because the bottles they were ordered for generally came in sets. Sometimes the nature of the contents of a bottle were engraved on its silver collar rather than on a separate label; these are possibly referred to in contemporary ledgers as 'crewitt labels'.

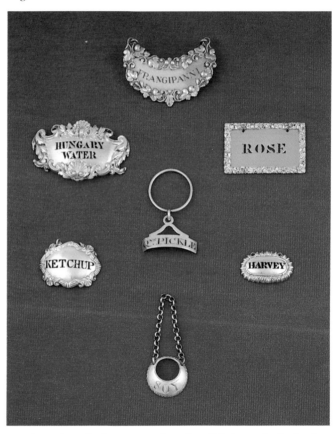

Labels for toilet waters and cordials

The variety of toilet waters, oils and cordials is equally fascinating. Many labels, especially those of the early nineteenth century, mark the extent and variety of home-made wines and cordials, whose birthplace was the still-room of nearly every country house. We can imagine that friendly rivalry which existed among the owners of particular and

14

special recipes for the preparation of the various beverages and cordials.

Apothecaries had also for centuries labelled their jars, bottles and flasks, albeit with parchment or paper labels. Aids to beauty were essential requirements for the Georgian lady, and many secret remedies were marketed. Mr Keypstick, an eighteenth century German quack, 'sold cosmetic washes to the ladies, together with teeth powders, hair-dyeing liquors, prolific elixirs and tinctures to sweeten the breath'. Strong perfumes had to mask what a regular use of soap and

15

water might have washed away. Lord Hervey wrote 'At Court last night there was dice, dancing, crowding, sweating and stinking in abundance as usual'. As the eighteenth century progressed, the excessive use of overpowering musk perfumes (so popular in the sixteenth and seventeenth

centuries) diminished with the introduction of 'sweet waters', and these had a number of additional advantages. Honey Water, a favourite containing essence of musk, cloves, vanillas, benzoin, orange-flower water, ordinary water and alcohol, imparted a charming light perfume and was excellent for smoothing the skin; it was also held to be an effective pick-me-up. The Balm of Mecca was another well known mixture; Lady Mary Wortley Montague found in 1717 that it made her face swell and her skin turn red (not surprising when one of the ingredients was turpentine); nevertheless Balm of Mecca was as highly esteemed by women in the nineteenth century as it had been in the eighteenth century. Other favourite brands such as Rose Water, Hungary Water and Eau de Cologne were not used only by ladies – in 1828 George IV's perfume bill was £500 17s. 11d., and Sheridan's favourite tipple was said to be a mixture of brandy, arquesbusade and Eau de Cologne. Glass bottles containing these mysterious mixtures, often decorated with silver mounts and furnished with silver tickets, were placed on dressing tables or in fitted toilet boxes.

12
Scent bottle, pressed and cut lead glass. Mark: Pellatt Patentee London (Falcon Glass house of Apsley Pellatt) 1831-1837. The bust of Queen Adelaide. c.83&a-1982
13
Frangipanni: late 19c. no marks M.674-1944; Hungary Water: 1826/7 Charles Rawlings M.595-1944; Rose: 1824/5 Charles Rawlings M.515-1944; Qns. Pickle: 1791/2 John Thompson M.18-1944; Ketchup: 1810/11 John Reily M.611-1944; Harvey: 1840/41 Reily & Storer; Soy: c.1790 no marks M.2-1944
14
Silver-gilt, English, mid-19c. M.639-1944
15
c.1830 no marks M.9-1944
16
1808/9 Phipps & Robinson M.118-1944

16

13

Trade cards of eighteenth and nineteenth century silversmiths give us an excellent idea of how skilfully they advertised their wares, often going to great pains to include minute illustrations on their cards (pl 23). Household inventories and accounts, and in particular silversmiths' ledgers show us how bottle tickets were sold, in what quantity, their weight and cost, and the type of client. Bottle tickets were often bought in sets, as we see in the accounts of the Earl Fitzwalter on 11 May, 1738, 'Paid Edward____, Silversmith in Lombard Street, for 14 tickets, silver for wine bottles at 5s.6d. each'. Slightly later, on 10 December, 1761, the Mayor and Corporation of Kingston-upon-Hull bought '12 crescent labills at £4 11s. 0d.' for the civic plate. These labels are later recorded as having been sold in 1836. During the 1760s, in the firm of John Parker and Edward Wakelin, Ansill and Gilbert, the resident workmen, were paid an average of 1s. per label for workmanship. The silver, supplied for them by the firm, cost about 1s.3d., making a net cost of 2s.3d. per label. However, the average retail price of a label sold by Parker and Wakelin was 5s.9d., suggesting a substantial mark-up of around 3s.6d. to cover the cost of maintaining a shop and their retail profit margin. However, Sheffield plate examples were much cheaper; in a manufacturer's catalogue in the 1780s they were advertised at 14s. a dozen.

The Wakelin ledgers also show that the firm gave credit to customers who 'traded-in' labels; other services included the repair of labels, polishing, alteration of arms, blacking the names and gilding. In some

To 9 plain pierced Bottle Tickets @ 5/6 ea

cases labels were sent to have their names changed and an entry of 1772 describes the 'taking out and re-engraving a label on a ticket'. The repair and replacement of chains is also referred to.

Fashionable motifs taken from pattern books played an important part in bottle ticket designs. The enamelled bottle tickets engraved by Ravenet and made at the Battersea enamel works in the 1750s were clearly influenced by Boucher (pl 30). Rococo motifs such as leaves, cherubs, elaborately chased and engraved crestings and bacchanalian derivatives are evident in many of the early labels. Neoclassical motifs

17
Entry from Parker & Wakelin Gentleman's (Client's) Ledger, 1781, f.1 Unlike the bulk of the Falkner order for tableware in this entry, the bottle tickets have clearly been taken from stock; there is no separate charge for making them.

Edward Falkner Esq.r D.r

1781

Brought from — Folio — 1			334	5	6

Nov 24

To a round Swage Lamp and Stand like Digbys the Lamp on a short plate 3.13 6 Eng.t about ... 22.13 ... 10.7.6

To 6 Oval fluted Salts with Handle ... 30.13 ... 5.11 ... 9.1.5

To Making 31/6 ea Gilding the inside Spring 7 Crests 3/ ... 11.2.

To 6 Plain Spoons fa 4 Crests 3/6 ea ... 2..4 ... 1.8.1

To 4 fluted Sauce Boats and Covers like Norkeys 82.16 9/8 ... 40..5

To Engraving 8 Crests ... 4

To 4 Plain Sauce Spoons ... 7..15 ... 5.11 ... 2..5..11

To Making 4/6 ea Eng 7 Crests 2/ ... 1..

To 2 doz Table Knives like Chesterfield ... 25..0 ... 5.11 ... 7..7..11

To 2 doz four pronged forks ... 57..7 ... 5.11 ... 16..19.4

To 3 doz Table Spoons ... 83.18 ... 5.11 ... 24..16.5

To Making the Knife Handles 2/3 ea forks 3/6 ea Spoons 2/9 ea 84 Crests 6 ea 24 Blades 1/ ea ... 16..

To 18 desert Knives to match ... 13.10 ... 5.11 ... 3..10.11

To 18 desert four pronged forks & 18 Spoons — ... 45.8 ... 5.11 ... 13.8.8

To Making the Knives 3/ea forks 3/ea Spoons 2/3 ea 54 Crests 6 ea ... 8..15.6

To 18 best London Blades 1/ea ... 18

To 6 Gravy Spoons of 2 Sizes ... 20.9 ... 5.11 ... 6.1

To Making 6/6 ea Eng 6 Crests 3/ ... 2.2.

To 18 polished Tea Spoons ... 9..14 ... 5.11 ... 2..17.6

To Making 1/2 ea Eng 18 Crests 9/ ... 1.10.

To a narrow Spoon for a Crust 4/6 ... 1.13 ... 14.4

To an Oval Bread & Muffin Tray Salts at 33/6 ... 5.13 — ... 3.0.

To a pair plain flatt Sided Tea tongs w.th Crest ... 1.5 ... 16

To a plain Soup Ladle fa and Crest 14/ ... 6.0 ... 2.9.6

To a Beaded Cheese plate ... 9.2 ... 5.11 ... 2.13.11

To Making 25/ Eng 1 ab't Crest 1a 1 a Tea Water plate 8/ ... 1.14.

To 9 plain pierced Bottle Tickets @ 5/6 ea ... 2.9.6

To 2 Mahogany Veneered Table Knife Cases to hold 12 Knives 12 forks and 12 Spoons in w.th Silver escutcheons plates & rings plated Hinges ... 4.8.

To 2 desert Cases to hold 9 Knives forks and Spoons in ... 37/6 ea ... 3.15

To Engraving 4 Crests on the Tops ... 6 ea ... 2..

To a Strong Iron bound Wainscoat Chest ... 6.10.

To a Sett of Strong brass wheel Castors 7/6 a Brass plate and Name 5/ makers and cording 2/6 paper shaving 9/ ... 1.5.

To a Red Leather Case for a Tea pot and Lady ... 1.19.

To a Large deal packing Case for Knife Cases ... 5.6

To 2 lb plate pow'r 4/ 4 Wax brows 4/ 1 Wood and 1 bony Brushes 7/ 2 Wash Leather Skins 3/ ... 18-

Carried to Folio 3			548	7	5

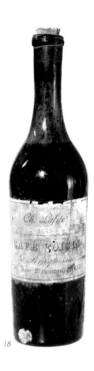

18

are reflected later in many of the silver and Sheffield plate labels which incorporate urns, goblets, ramsheads, husks, swags and ribbons. Under the influence of Regency taste wine labels became more opulent, appropriately using naturalistic ornament, often in the form of grapes and clusters of vine leaves. A notable example is the leopard's pelt design from the manufacturing workshop of Storr & Co. for Rundell Bridge and Rundell, based on a detail from the Warwick Vase. Indeed, Rundell Bridge and Rundell, Royal goldsmiths, succeeded in promoting a demand for these large heavy, ornate labels which were displayed to great effect on the glass decanters of the period. A fine selection of Regency wine labels (pl 19) evokes the sumptuousness of the period and illustrates the high standard of workmanship which prevailed in the more successful firms.

At the end of the eighteenth century and for some thirty years afterwards, there was a tremendous upsurge in the output of bottle tickets. This was largely due to the perfecting in the 1790s of the die-stamping process by Matthew Linwood of Birmingham, enabling labels of the most intricate and complicated design to be manufactured in large numbers from sheet metal with the minimum of handwork. Growing prosperity, arising partly from an expansion in our overseas trade and from the industrial development in the Midlands, led to an increasing demand for luxury goods. A more even distribution of wealth created a middle class anxious to imitate the lifestyle of the upper classes. The manufacturing of bottle tickets spread to many towns in England, to Scotland and to Ireland from the 1750s.

By the middle of the nineteenth century the use of the bottle ticket had declined, due to a number of factors, another shift in the fashion for tableware being an important one. Ornately mounted cut-glass decanters left little room for bottle tickets and wine bottles were now appearing more often on the table. Printed labels were in general use by the 1840s (pl 18) and in 1861 Gladstone's 'Licensed Grocers' Act' made it legal to sell wine by the single bottle (providing it was labelled). A paper label pasted on a bottle is a poor substitute for an elegant decanter label but the public, ever pursuing novelty and economy, quickly discovered that the wine tasted none the worse. Label designs became stereotyped with an emphasis on geometric and architectural motifs

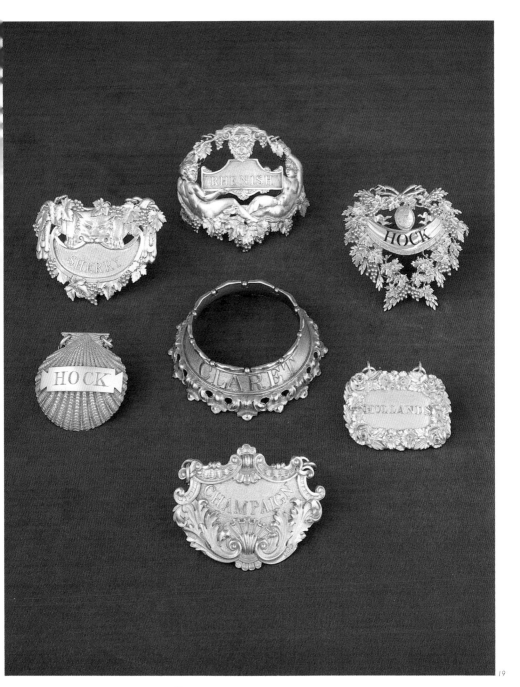

17

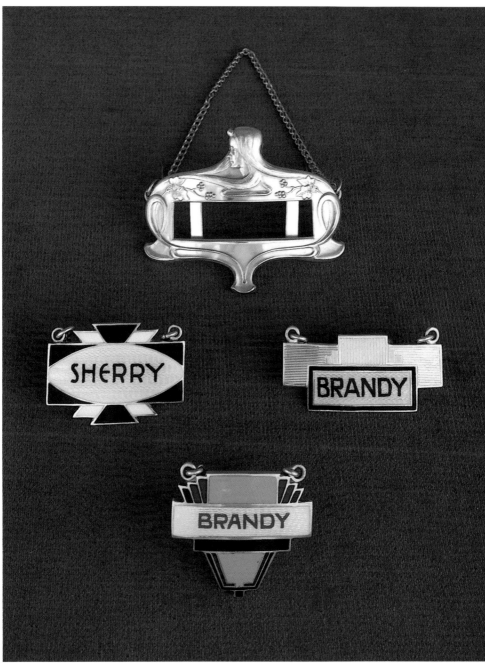

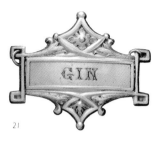

21

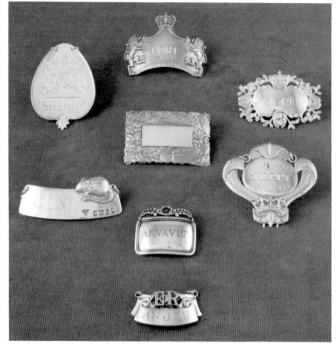

22

20
Slot label: German c.1910 (Michael Parkington, Esq.);
Sherry: Birmingham 1933/4 Turner & Simpson
(Michael Parkington, Esq.); Brandy: Birmingham
1933/4 Turner & Simpson (Michael Parkington, Esq.);
Brandy: Birmingham 1937/8 Turner & Simpson
(Michael Parkington, Esq.)
21
Electroplated, c.1890 M.345-1944
22
Port: 1952/3 Leslie Durbin (Captain Sir Thomas
Barlow); Sherry: Sheffield 1977, Roberts & Belk
(Photograph Courtesy of Judith Banister); Mead: 1978
J.M. Flitton (Captain Sir Thomas Barlow); Uninscribed
label: Silver-gilt 1984 Stuart Devlin (Stuart Devlin,
Esq.); Gin: 1977 B.L. Fuller (Captain Sir Thomas
Barlow); Sherry: 1981 Alex Styles for Garrard & Co.
(Captain Sir Thomas Barlow); Akavit: Swedish cc.1960
Georg Jensen (Michael Parkington, Esq.); Anjou:
1952/3 L.A. Crichton (Captain Sir Thomas Barlow)

(pls 21,50), and as old label dies wore out there was no call to replace them.

Despite the fall from fashion of wine labels in the latter part of the nineteenth century, labels continued to be made, but more often for the spirit tantalus than the wine decanter. In an illustrated catalogue issued by Elkington & Co. in 1885, seven types of labels are shown, with electroplated labels costing approximately half that of silver examples, showing that demand for labels had not entirely died. Attractive examples of Art Nouveau and Art Deco wine labels do exist (pl 20) and wine labels of original design are still being made today. These are often prompted by a commission inspired by a special occasion, such as the Royal Wedding in 1981, instead of being manufactured as an essential part of everyday life as they were in the eighteenth century.

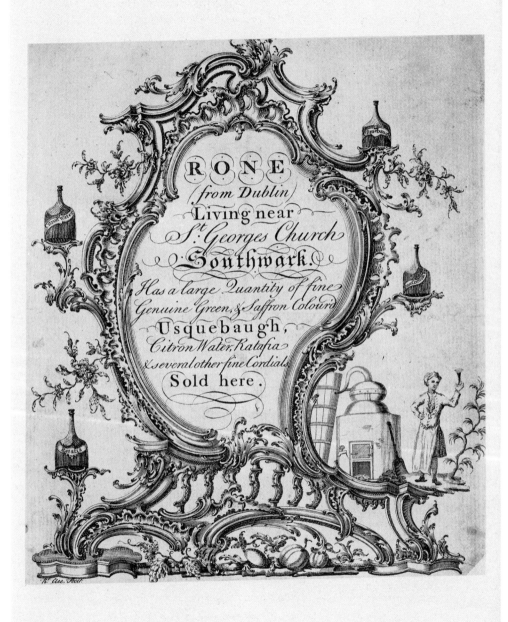

23

Hallmarking, techniques and materials

Hallmarking practice in the eighteenth century was such that it is difficult to date precisely the earliest surviving bottle tickets. In 1738 'The Plate Offences Act' ordained that marks on silver should consist of the maker's mark, town mark, the standard mark and the date letter. A list of exemptions (weighing less than 10 pennyweight) to this act included numerous small articles but there was no mention of bottle tickets, presumably because at this stage they were being used in small numbers in wealthy private households, and so were not a significant part of the Assay Office's business. After 1738 one may therefore expect labels to bear a maker's mark but not necessarily any other.

On May 1, 1777, a list of amendments to the 1738 Act was compiled and this included a mention of bottle tickets indicating that from this date bottle tickets were required to be assayed and fully marked. In the 'Plate Duty Act' of 1784 a tax of 6d. an ounce on all silver was imposed (except for the list of exemptions previously listed). The Act also ordained that the King's Head duty mark was to be stamped in each assay office in England and Scotland. In 1790 the 'Marking of Silver Plate Act' reviewed the clauses of previous Acts and from this date bottle tickets assayed in England and Scotland should bear four or five marks: the maker's mark; the standard mark; the town mark; the annual date letter and the King's Head duty mark.

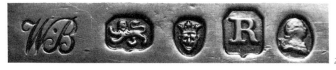

Despite all these Acts it is quite possible to find incomplete marks on a label after 1790; these newly-imposed laws were not always followed. There are, however, other clues in the dating of a label that is not fully marked. Providing the label is clearly marked with the lion passant, a knowledge of the changing form of the shield containing the lion passant and the shape of the lion itself may make it possible to place an approximate date on the label (pl 25). Another guide is the changing form of a maker's mark. It must be remembered however that hallmarks can be erased by piercing on the label, by constant wear or damage, and lastly one must always be on the look-out for later-struck or transposed marks on labels, as on all silver.

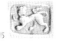

23
Trade card; Rone from Dublin c.1740 (The Metropolitan Museum of Art, gift of Mrs Morris Hawkes, 1927)
24
Marks taken from candlestick London (1812) Incuse mark of William Burwash (The Worshipful Company of Goldsmiths)
25
Lion passants: 1729-1739; 1739-1755; 1786-1821 (The Worshipful Company of Goldsmiths)

The three main techniques employed in the basic forming of a label are handraising, casting and die-stamping. Generally all three techniques are easily recognisable with close inspection and, more important, handling.

Handworked labels

The required shape was marked directly on to a sheet of silver or alternatively the design would be traced on paper, and the paper stuck on

the face of the sheet metal. The rough shape would then be cut out with hand shears, and the outline trimmed and finished with a file. An important aid to the silversmith for the handworked label (as well as for the diestamped technique) was the introduction in the 1720s of rollers for producing sheet metal. This technique was further improved by water-powered and horse-powered rolling mills in the 1750s, and steam-powered in the 1790s, enabling silversmiths to work with even thinner sheets of silver.

As a result goods became cheaper and available to a wider public. Handworked labels at their best were exquisitely flat-chased and engraved, the limitations of the methods employed giving them a certain charm that diestamped and cast examples lack. Their distinguishing features are filing at the edges of the label, hammermarks on the reverse of the label, and impressions from the chasing tool on the back.

Cast labels

These were produced with the help of one or more moulds. The master label was worked in a soft metal, usually lead. Using two boxes,

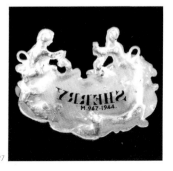

this master label was then pressed in a malleable substance firm enough to take an impression (such as very fine sand). The two halves were put together to form a mould and molten silver was poured in through a narrow hole. When cool, the moulds were removed leaving the silver label in

a rough state to be touched up, chased and engraved by hand. For complicated designs a mould in several parts was necessary. It was crucial that the original mould should be crisp with fine detail, although the handwork carried out on the label after casting could greatly improve a poor casting. Distinguishing features of this method are pitting on the back of the label, caused by air bubbles incorporated during the casting process, a good weight and solid appearance. The panel of the label would usually be left blank to be engraved or pierced later to meet the customer's requirements. Specially-commissioned labels might have the name incorporated in the casting.

Die-stamped labels

This art was perfected and made popular by a Birmingham silversmith, Matthew Linwood, in the 1790s although die-stamped

28

labels are known from the mid-eighteenth century; indeed, silversmiths had experimented with the idea for hundreds of years. As in casting, the essence of die-stamping lies in the quality of the dies. The craftsman takes a small block of hardened steel and carefully hollows out every tiny detail of the required design in reverse so that it fits exactly into another prepared die. This too is hardened. When the two dies, intaglio and relief, have been prepared, they are inserted into a fly or hydraulic press, or drop stamp. A piece of metal is placed over the first die and the press is operated. The metal is forced into the first die by the second die to create the desired shape; after this initial stage it is a simple matter to stamp out labels in great quantities and at a comparatively small cost. Distinguishing features of die-stamped labels are lightness, and fine detail that has a smoother appearance than handworked or cast labels. The reverses of these labels are hollow or stamped and sometimes in a heavier gauge metal to give the appearance of being cast.

Because of the constant plagiarizing of designs, caused by lower commercial ethics and demand for cheap die-stamped goods, an Act was passed in 1798 which gave protection to a craftsman's design for fourteen years after its first issue. This Act was passed because some

26
mid-18c. Sandylands Drinkwater M.709-1944 (reverse)
27
1825/6 Edward Farrell (for Kensington Lewis) M.967-1944 (reverse)
28
1840/1 Reily & Storer M.891-1944 (reverse)

silversmiths were taking casts of others' wares as a cheap means of obtaining versions of popular subjects. This Act did not solve the problem entirely, as the silversmiths involved merely used the same pattern, purposely introducing small differences of detail to avoid flagrant infringement of the law.

Names on labels

These names were executed in a number of ways:

1 Handscratched or engraved (sometimes filled with black paint-like substance)

2 Pierced (a) with a chisel, until c.1760, (b) with a fine saw

3 Letter punches (these were first used by the Bateman family, and were chiselled at the edges to create a hand-finished appearance)

4 Cast and applied as single letters

5 Cast or die-stamped with the body of the label

6 Engraved as a separate strip and slotted into the back of the label

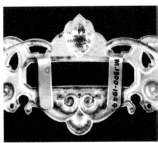

24

Notable borders Firms used numerous different borders to embellish the labels. These were influenced by current fashions in engraved and applied ornament. Methods employed varied greatly. A gadrooned border, for example could be made separately and then soldered or riveted to the main body: alternatively it was die-stamped or cast with the whole label. Bright cut engraving lent itself to great effect in the borders of wine labels and was popular in the last thirty years of the eighteenth century. Common borders included the following:

1 Feathered

2 Gadrooned

3 Ropework or Cablework

4 Pierced work

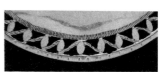

5 Plain engraved lines

6 Zig-zag or wavy

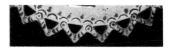

7 Bright cut decoration

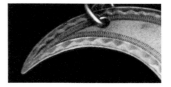

Apart from the silver and silver-gilt tickets, which form the subject of this publication, other materials have been employed for bottle tickets. These include:

Enamels	Electroplate	Papier-mâché	Brass
Mother-of-Pearl	Gold	Japanned tin	Leather
& other shell	Pinchbeck	Lead	Glass
Ivory	Britannia Metal	Zinc	Brocade
Tortoiseshell	Paktong	Pottery	Wood
Sheffield plate	Tutenag	Porcelain	

Enamels

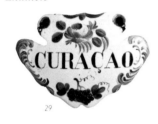

29

Enamel labels were made from metal, usually copper, cut to the desired shape and then covered with a vitreous coating made opaque with oxide of tin and then decorated. They are generally escutcheon-shaped. Two processes were adopted in the decorating of enamel bottle tickets: transfer enamels and painted enamels.

The transfer-printed label was decorated by the application to a flawless milk-white enamelled surface of an impression from an engraved copper plate, printed on paper in specially-prepared adhesive inks, usually black, but also varying shades or red, brown, purple or mauve. The label is given a second firing in the kiln to fix the print, which often depicted putti and the name of the wine.

It is to this first category that Battersea enamel bottle tickets belong; they were made at York House, Battersea from 1753-1756 by the firm of Hansson, Delamain and Brooks (which went bankrupt in 1756). The chief designer was probably James Gwin, an Irish artist, although John Hall and John Brooks also worked there. The engraver, and occasional designer, was Simon François Ravenet who originally came to London from Paris to work for William Hogarth.

The second category of labels, i.e. painted enamels, were largely produced in Bilston, Wednesbury and South Staffordshire. In addition redundant designers from the Battersea factory are known to have moved on elsewhere in London and even to Birmingham to work. The enamels are painted in clear lustrous colours with dainty floral sprays surrounding the inscriptions and grapes. The edges have a scroll design in brown and yellow. Many imitations of these labels were made by Samson (Paris) in the late nineteenth and early twentieth century.

29
Curaçao: enamel, English c.1780, C.7C-1948
30
Rota: enamel, Battersea 1753-6 Ravenet C.5K-1948;
Brandy: enamel, Battersea 1753-6 Ravenet
C.5A-1948; Ale: enamel, Battersea 1753-6 Ravenet
C.5-1948; Rhenish: enamel, Battersea 1753-6
Ravenet C.5-1948; Cape: enamel, Battersea 1753-6
Ravenet C.5B-1948; Hongrie: enamel, Battersea
1753-6 C.5f-1948

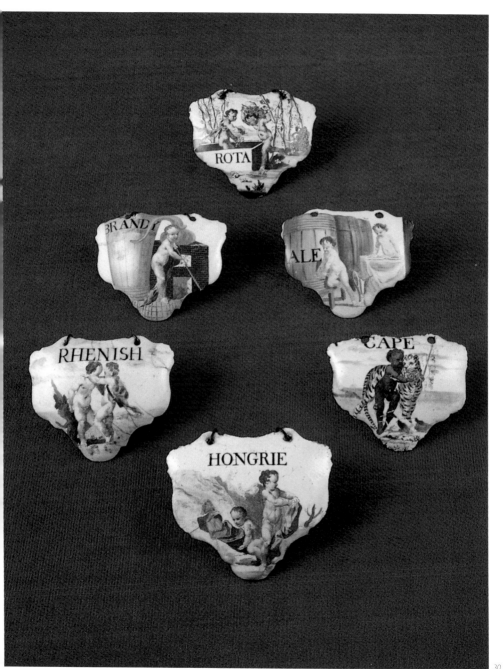

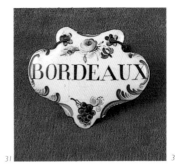

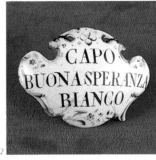

Mother-of-pearl

Mother-of-pearl labels are known for their delicately engraved faces, sometimes with intricate piercing. They were often crescent-shaped, but escutcheons, rectangles, ovals and rings were based on silver prototypes. Most of the mother-of-pearl came from the Far East, and in the nineteenth century Birmingham became the centre for the working and distribution of mother-of-pearl, although little is known of the actual craftsmen concerned.

Ivory

Ivory was imported from South Africa and the Far East, and ivory workers used the natural form of their material to produce splayed hoops which encircled the neck of the decanter. Such hoops were cut concentrically from the elephant's tusk, thus no two were exactly the same shape or size. They were also made in tablet-form with occasionally long ivory chains. Ivory is difficult to date; the very nature of ivory makes it assume an aged appearance very quickly. Water, wine, oil and grease soon turn it yellow and Asiatic ivory remains white only a comparatively short time.

Tortoiseshell

As with mother-of-pearl, the centre for working tortoiseshell was Birmingham. Tortoiseshell was in fact turtle shell; wine labels of tortoiseshell were never produced in large numbers and occur mainly in the nineteenth century when novelty labels became more popular.

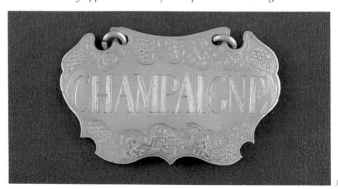

Porcelain and pottery

Spirit labels of pottery were a speciality of Zacharius Barnes of Liverpool from the 1780s. These were decorated with sepia transfer engravings. Other potters made bottle tickets in the nineteenth century (pl 38) but mostly poorly inscribed coarse ware. In addition large quantities of porcelain labels came from France in the nineteenth century.

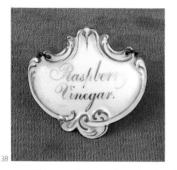

Gilt metal

Gilt metal examples of wine labels occur in the eighteenth and nineteenth centuries, the most well-known type being pinchbeck. Pinchbeck was invented by Christopher Pinchbeck (in the 1720s). It was an alloy containing copper and zinc (the recipe was never divulged). It is quite rare and, in the case of wine labels, they were always handworked. In appearance it closely resembles gold (pl 39) and a slight wash of gold was occasionally applied to the surface to prevent tarnishing.

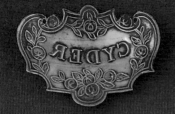
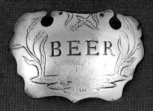

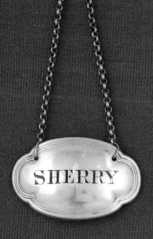
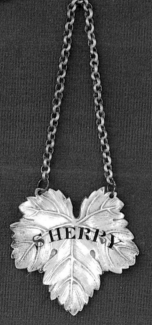

Sheffield plate

The technique of Sheffield or fused plate was probably discovered by Thomas Boulsover, who first used it for making buttons; slightly later it was employed extensively in Sheffield, Birmingham and London for domestic ware. Briefly, an ingot of copper was covered top and bottom with two sheets of silver and the metal fused together by a combination of extreme pressure and heat; this was brought to the required thickness in a rolling mill, the silver and copper maintaining the same proportionate thickness throughout. Labels were then stamped from these sheets, the escutcheon being a popular shape initially. Sheffield plate was occasionally marked before 1772. Silver edges, stamped and applied were invented by Samuel Roberts and George Cadman to conceal the fused edges. Early examples of Sheffield plate wine labels are plated on one side only and therefore have copper backs (pl 40).

Electroplate

During the early years of the nineteenth century, chemists had been working towards the electrical deposition of gold and silver on a base metal, usually nickel. By the mid-1830s, due to the efforts of George Richards Elkington and his associates of Birmingham, success was close. In March 1840, G. R. Elkington and his cousin Henry took out a patent for the new process; a process which had been perfected by a surgeon, John Wright. While sterling silver was used in the making of Sheffield plate (that is 925 parts pure silver and 75 parts copper alloy) electroplating required the use of pure silver. The use of pure silver gives electroplated work a white appearance, whereas Sheffield plate tends to look blueish, with the worn surface often revealing copper (pl 40).

Other metal finishes and alloys occasionally used by makers of bottle tickets included close-plating (the earliest of the plating techniques) and silver coloured alloys such as tutenag and paktong, and Britannia metal.

40
Cyder: copperback Sheffield plate c.1760
M.740-1944; Beer: Sheffield plate c.1760
M.702-1944; Grape: Sheffield plate c.1820
M.270-1944; Sherry: electroplated Britannia Metal
c.1870 M.180-1944; Sherry: electroplate c.1850
M.806-1944

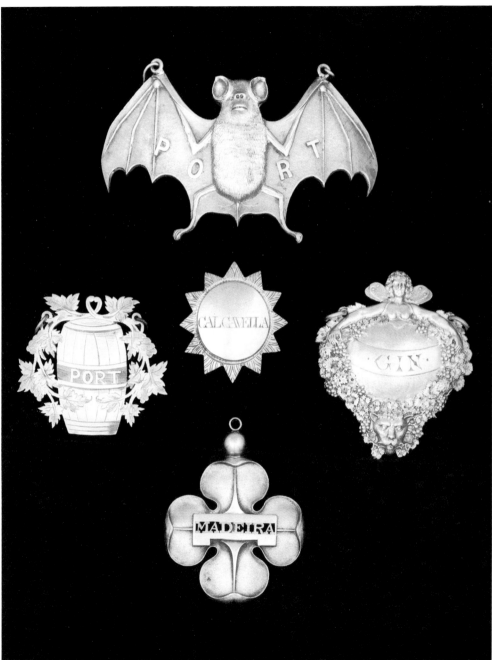

Some common styles

A wide variety of styles and shapes has been recorded for bottle tickets. This section has therefore been compiled in broad terms; there are many variations on the basic shapes discussed and illustrated here. Merely by looking it is not possible to date bottle tickets stylistically, particularly in the case of provincial versions which tended to lag behind the large cities anyway, although in some towns in Scotland and Ireland, silversmiths produced patterns unique to their area which were never made in London, Birmingham or Sheffield. As in all silverware, from about 1800 many labels were made to earlier designs and these designs tended to remain in production or to be revived. There are also many designs which do not belong to any of the standard groups described below, some being private orders or the whim of an individual silversmith (pl 41). In addition, a mass of revived styles in the Victorian period make it virtually impossible to attempt more than a very broad classification of types.

Escutcheon

Dating from the 1730s

The shape of this label appears to have been inspired by the brass handles and keyhole plates on furniture of the Queen Anne and early

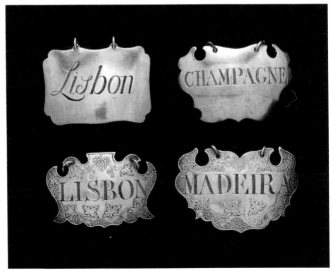

41
Port: electroplate, late 19c. M.1016-1944; Calcavella: 1792/3, maker's mark RB M.317-1944; Port: late 19c. no marks M.1093-1944; Gin: c.1820 Atkins & Somersall M.946-1944; Madeira: Paul Storr for Rundell, Bridge & Rundell M.1099-1944

42
Late 18c. Thomas Heming M.271-1944

43
Lisbon: c.1750 Edmund Medlycott M.721-1944; Champagne: c.1745 Sandylands Drinkwater M.84-1944; Lisbon: c.1750 no marks M.69-1944; Madeira: c.1750 John Harvey M.720-1944

42

43

Chippendale periods ('Designs for the Metal Trades', V&A, 1913). These labels tend to be slightly convex in shape; they can be plain, or flat-chased and engraved with vine leaves and grapes. Usually the name of the wine is scratched-in with a lettering tool, often filled with a black paint-like substance, but it is also occasionally pierced.

Rectangular
Dating from the 1730s

These were flat or convex and varied in size and proportion. Early examples tended to be plain although they sometimes have delicately pierced domes. Engraved crests could be ordered. Early rectangles had sharp corners but by c.1785 they were clipped and rounded. Feathered edges were the earliest borders, later followed by reeded borders and then bright-cut and zig-zag borders. The name of the wine was engraved or pierced.

Later rectangles were notably deeper and larger. These also had domes or crests and an even greater variety of borders. Escallop shells were often incorporated at the corners, or mid-points of the sides.

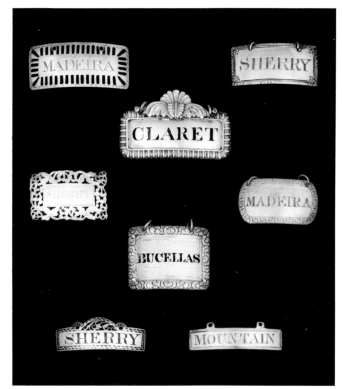

44
Madeira: 1784/5 Susanna Barker M.1025-1944; Sherry: 1815/16 James Aldridge M.1046-1944; Claret: 1813-14 Thomas Robinson M.591-1944; Sherry: Birmingham 1829/30 Ledsam, Vale & Wheeler M.1074-1944; Madeira: Birmingham 1811/18 Lawrence & Co. M.294-1944; Bucellas: 1825/6 Thomas Edwards M.511-1944; Sherry: late 18c. Margaret Binley M.10-1944; Mountain: Birmingham M. Boulton & Co. M.290-1944
45
Brandy: Newcastle, late 18c. R. Pinkney M.422-1944; Mountain: c.1780 Hester Bateman M.494-1944; Madeira: c.1790 Hester Bateman M.1037-1944; Rum: c.1790 no marks M.909-1944; Shrub: Aberdeen, early 19c. J. Douglas M.429-1944; Madeira: c.1750 Jonathan Robinson M.400-1944; Sherry: c.1780 Hester Bateman M.390-1944

Kidney and Crescent
Dating from the 1740s

Kidney shapes were as the name suggests, with simple reeded or feathered borders. Crescents may have been inspired by the metal gorget worn round the neck by army officers during this period. Early examples tended to have rather close horns. These also have shields or engraved crests, or even an urn (upon which a crest might be engraved) between the two horns. Later crescents tend to be more open and to have delicate bright-cut edges and a variety of other edges; sometimes the horns are engraved with floral designs. Another variation on the crescent style has a cusp on the upper edge. The name was engraved or pierced.

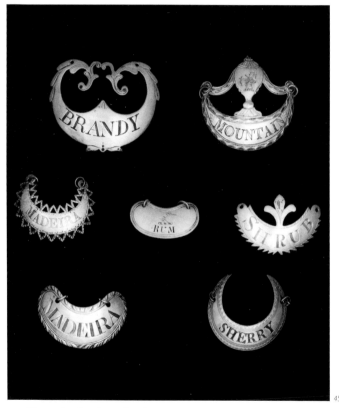

45

Scroll
Dating from the 1760s

These simulated scrolls of paper and were in the form of a narrow ribbon, one end turning up and the other down; alternatively both ends of the scroll rolled down (pl 46). Occasionally these had shields on the top side, borders were varied and a particularly striking example has a dog-tooth pierced border (pl 46); swags were sometimes incorporated.

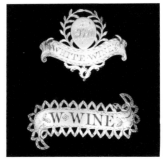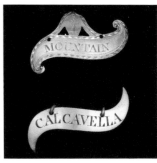

Oval and navette
Dating from the 1770s

Sometimes these are plain but otherwise with a variety of borders, the most spectacular being the pierced examples (the navette shape which has pointed ends tends to be later). The names were engraved or pierced.

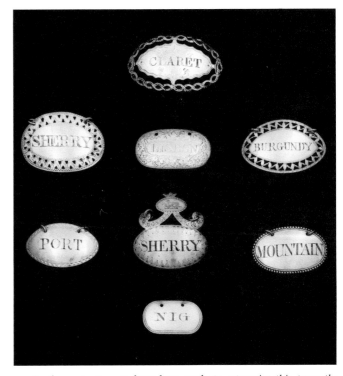

Bacchanalian
Dating from the 1730s

In the past attempts have been made to categorize this type; the earliest date from 1730s, with a marked revival from c.1805. The basic shape was an asymmetrical cartouche. Themes from the full repertoire of classical ornament relating to Bacchus and his followers occur; earlier

examples tend to be decorated with vines, tendrills and grapes, perhaps with two putti (pl 49) and a satyr below, this latter label being one of the earliest, now rare, examples. Many of these dies were re-issued in the early nineteenth

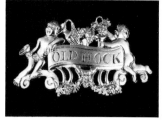

49

century. Later examples, dating from c.1805 onwards were variations of this, but more intricate and introduced other figures and animals such as foxes, boar's heads, fauns, jugs, wicker baskets or architectural features. The name of the wine is engraved or pierced on a narrow scroll (pl 56).

Generally with richly-decorated embossed or applied rococo-revival borders. Many of them incorporate architectural features such as acanthus leaf decoration, volutes and scrolls.

Cartouche
Popular from 1840-1900

50

46
White Wine: c.1780 Susanna Barker M.484-1944;
W.Wine: late 18c. Walter Tweedie M.1042-1944
47
Mountain: early 19c. Susanna Barker 1270-1903;
Calcavella: c.1780 no marks M.60-1944
48
Claret: c.1775 Hester Bateman M.1059-1944;
Sherry: 1844/5 Rawlings & Summers M.1033-1944;
Lisbon: 1802/3 Andrew Field M.533-1944; Burgundy:
c.1785 Phipps & Robinson M.1030-1944; Port: late
18c. Phipps & Robinson M.205-1944; Sherry: 1784/5
Phipps & Robinson M.437-1944; Mountain: 1784/5
Thomas Heming M.205-1944; Nig: 1818/19 Thomas
and James Phipps II M.169-1944
49
c.1760 no marks M.908-1944
50
Electroplate, c.1890 M.344-1944
51
Marsala: 1842/3 Rawlings & Summers M.349-1944;
Madeira: 1827/8 Emes & Barnard M.558-1944;
Tinta: 1841/2 Reily & Storer 1259-1903; Burgundy:
1810/11 John Robert 1260-1903; Hollands: 1816/17
William Eley M.971-1944; Port: 1828/9 Emes &
Barnard M.785-1944

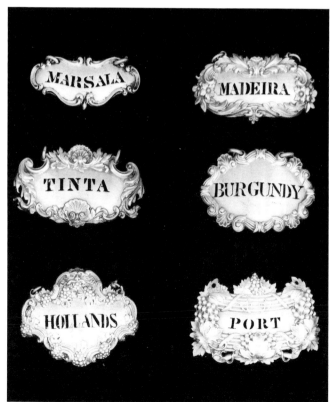

51

Urns, goblets and festoons

Dating from the 1770s

The early version of this style was a simple neoclassical urn and drapery. These delicate and elegant labels were made in large numbers in the workshops of Hester Bateman and her family successors

and Thomas Phipps and Edward Robinson. In the 19th century this design was elaborated into a more solid sumptuous version, one heavy swag perhaps being held up by two putti, or swags and vine leaves.

Shells

Dating from c.1800

Many types of shell were used for this design, sometimes stylised, sometimes naturalistic, the name plate being cut into a panel in the ribs of the shell.

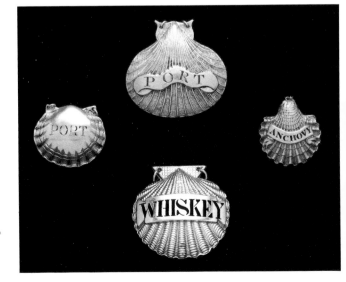

52
c.1785 no marks M.503-1944
53
1807/8 Paul and William Bateman M.463-1944
54
1846/7 John Samuel Hunt for Hunt & Roskell
M.791-1944
55
Port: Birmingham 1810/11 Matthew Linwood
M.581-1944; Port 1831/2 Maker's mark
indecipherable M.576-1944; Anchovy: 1815/16 J.
Story and William Ellicott M.577-1944; Whiskey:
early 19c. no marks M.584-1944
56
Port: 1817/18 George Pearson M.942-1944; Claret:
1825/6 Charles Rawlings M.752-1944; Madeira:
1817/18 Daniel Hockly M.939-1944; Claret: 1838/39
Samuel Marshall M.959-1944; Sauterne: 1822/23
Dumee & Holmes M.939-1944; Rum: Birmingham
1823/4 J. Taylor M.929-1944; St. Perez: 1805/6
Phipps & Robinson

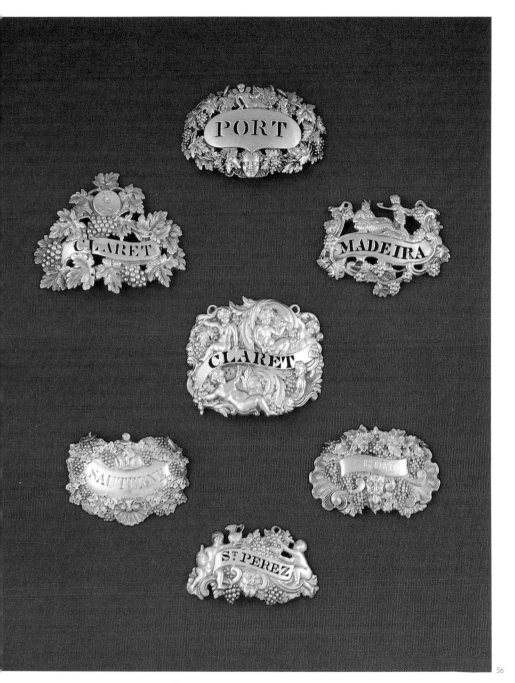

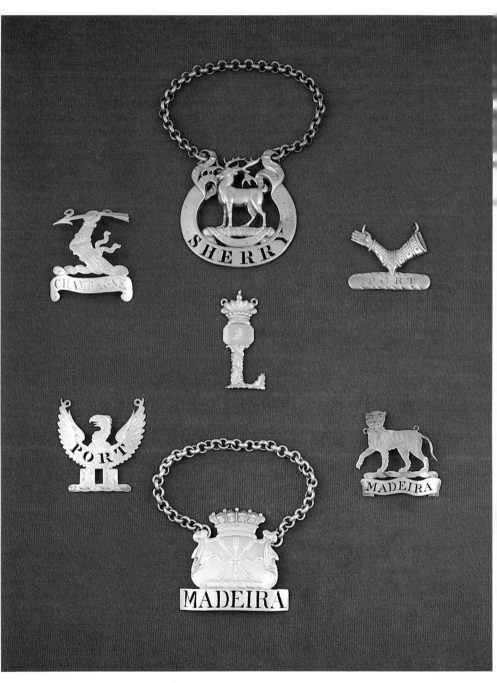

Vine leaf
Dating from c.1810

Consisting of one, two or three leaves, sometimes on their own or suspended from tendrils. Designs may incorporate bunches of grapes and they were produced in a variety of sizes. The name of the wine on these was nearly always pierced, and the label diestamped, although some very handsome cast versions were executed. Unusual variations on the leaf theme are the oak leaf and the acanthus leaf.

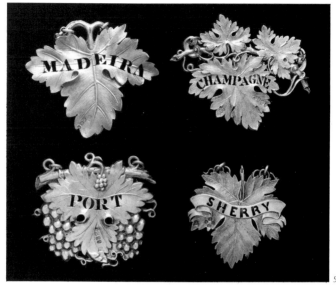

58

Heraldic
Dating from c.1760

A personal crest forms the dominant feature of heraldic labels, commissioned by private individuals, regiments, livery companies and other institutions. They are amongst the most sought-after of labels, as a set is almost certain to be unique (pl 57).

57
Sherry: 1826/7 Garrard & Co. M.1002-1944;
Champagne: mid-18c. Sandylands Drinkwater
M.1109-1944; Port: 1795/6 John Harris
M.1114-1944; L: Dublin 1829/30 Smith & Samble
M.1161-1944; Port: 1852/3 E & J Barnard
M.1006-1944; Madeira: c.1775 Hester Bateman
M.398-1944; Madeira: 1829/30 Benjamin and James
Smith M.397-1944

58
Madeira: 1835/6 Benjamin Smith M.811-1944;
hampagne: 1825/6 John Reily M.848-1944; Port:
1840 Rawlings & Summers M.900-1944; Sherry:
865/6 R & A Garrard & Co. M.796-1944

59
: electroplate, late 19c. M.1165-1944; R:
799/1800 Phipps & Robinson M.1223-1944; W:
mid-19c. no marks M.1174-1944; P: electroplate late
9c. M.1236-1944

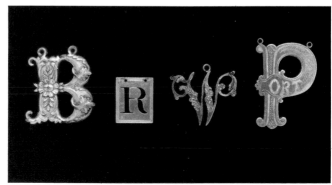

59

Capital letters & cut-out words
Single letters
Dating from the 1780s

Three types; the first have a 'stencil' appearance in which the letter has been punched out of the usually rectangular panel. These look like postage stamps in outline, and are the earliest type. Second, labels cut out of sheet metal or diestamped to the shape of the letter. These were plain or engraved with designs. Thirdly, the single engraved letter, which was a single letter engraved on almost any shape of label. These letters tend to be Roman capitals, more rarely script and occasionally Gothic characters (pl 59).

Cut-out words
Popular from 1840-1900

These were generally electro-plated and catered for the more popular 'novelty' market. In these, as the name suggests, a pierced name formed the whole label, the lettering either in Gothic or Roman capitals, script or cusped floral lettering amongst other rarer types. Sometimes the openwork letters are surrounded by a frame of fretwork design.

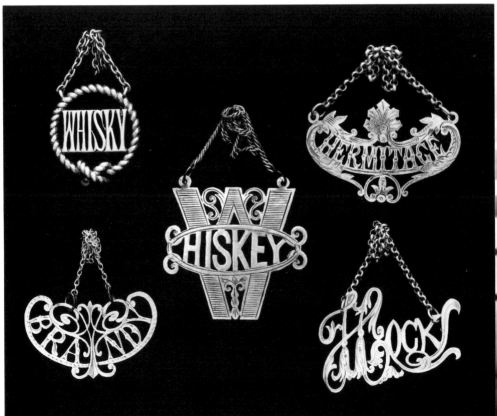

60

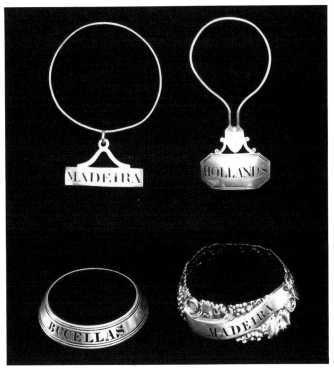

61

Neckrings

Dating from the 1790s

Three categories: first, splayed hoops, often of mother-of-pearl and ivory, as well as being made in silver and electroplate. Silver examples can be embossed with vines and grapes but more frequently these were plain, with the name pierced out. They come in three sizes; cruet bottles, pickle jars and decanters. Secondly, a very thin semi-oval or round ring, with the name plate hinged from it, or suspended by chains in the shape, for example, of a rectangle or an oval. Crests were popular on these. Thirdly, a type similar to the ring and hinged name plate, but shorter, i.e. the name plate hanging directly from the neckring. A rare form of neckring was that in which the silver ring or band is cemented to the ground-down neck of the decanter, with the name of the contents engraved on it.

60
Whisky: c.1870 no marks M.1268-1944; Hermitage: electroplate late 19c. M.1279-1944; Bucellas: electroplate 1856-58 Elkington & Co. M.12-1944; Brandy: electroplate late 19c. M.1279-1944; Hock: electroplate late 19c M.1284-1944; Whiskey: electroplate late 19c. M.1273-1944

61
Madeira: 1791/2 John Tweedie M.33-1944; Hollands: 1793/4 Phipps & Robinson M.39-1944; Bucellas: 1856-58 Elkington & Co. M.12-1944; Madeira: c.1830 no marks M.15-1944

62
Cut-glass decanter, silver mounts, English 1805/6 Henry Nutting (Michael Parkington, Esq.)

62

43

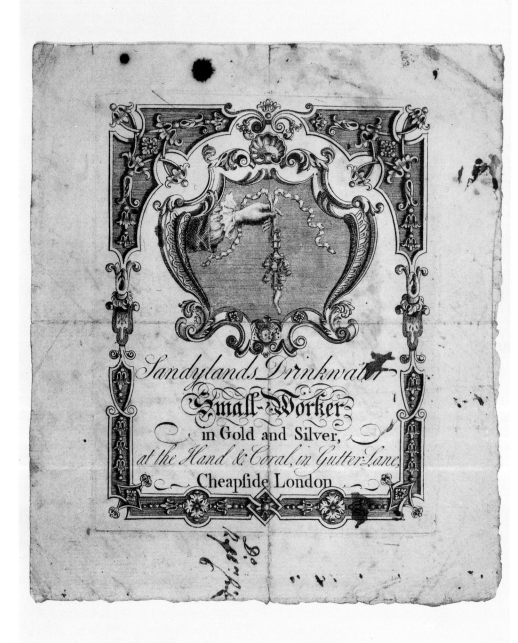

Sandylands Drinkwater
Small-Worker
in Gold and Silver,
at the Hand & Coral, in Gutter-Lane,
Cheapside London

63

Some notable producers of wine labels

A study of the firms which were known to produce bottle tickets in the eighteenth and nineteenth centuries reveals that close commercial and family relationships existed. Pirating of designs, and sharing of patterns and dies was widespread. Some workshops continued in existence for many years, and a continuous link between families can often be traced. Such is the case with Sandylands Drinkwater, who first entered his mark in 1735 and whose firm can be traced down to the partnership of Charles Reily and George Storer who entered their first joint mark in 1829; the latter almost certainly re-issued inherited dies (pl 51), to cater for the revived taste for rococo design, first used long before, in the 1740s. In other cases strong family links existed between firms which are quite evident in a comparison of their work. In addition, as research is revealing, the maker's mark (as it is generally termed) struck on a piece of silver does not necessarily identify the designer or the actual maker of the piece. The mark is that of the owner of the manufacturing workshop (or sometimes the retail company) namely the sponsor who takes responsibility for the finished product when it is sent to the assay office, thus raising the whole question of supply and demand between wholesalers and retailers.

65

Not surprisingly few firms concentrated solely on the production of the relatively unimportant bottle ticket. Some silversmiths such as Richard and Margaret Binley who respectively entered their marks 1760 and 1764 and Susanna Barker working from c.1778 did specialise in producing bottle tickets of a distinctive design (pl 44). Sandylands Drinkwater and John Harvey were among the first silversmiths to produce bottle tickets in the late 1730s (the former seems to have made both bottle tickets and rattles). Both perfected the art of hand-worked labels in particular the flat-chasing and engraved decoration, and we can admire the richness of modelling in their cast bacchanalian labels. Other notable silversmiths of this early period who made wine labels are Lewis Hamon, Thomas Rush and Edmund Medlycott.

In the later eighteenth century, silversmiths became increasingly aware of the potential of mass-production. One of the most important of these new manufacturers was Hester Bateman (first mark entered 1761) and her family of Bunhill Row, London. The business was obviously

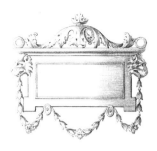

66

established for quick production, and the large volume of their work surviving is convincing evidence, although this in no way appears to have affected the innovatory designs and high standard of workmanship achieved by the family. Among the labour saving techniques they adopted was letter punching. They also had one of the first steam-powered sheet rolling mills in London.

The originality and elegance commonly associated with the Bateman family's products (pl 45) is seen also in wine labels (some to identical designs) coming from the Phipps & Robinson workshop (pl 48). This family business had been founded by James Phipps in 1767. His son Thomas, and Edward Robinson II (their first mark entered in 1783) continued the business and perfecting the use of bright-cut engraving, so popular on all domestic silver at this time. The workshops of John Rich, Elizabeth Morley, and James Hyde also produced some fine wine labels during the later part of the eighteenth century.

It soon became obvious, however, that the London makers, traditionally leaders in design and production, now had to compete in an ever-expanding market with the more commercially-minded men of Birmingham and Sheffield. The simplicity of neoclassical forms was admirably suited to the new techniques of factory production which were revolutionising the market. Notably, from 1764 the new partnership of John Fothergill and Matthew Boulton, based in their Soho Manufactory in Birmingham, produced fine designs in the neo-classical manner, marrying quality to quantity. Boulton had an opportune sense of taste and in a letter to a relative he states: 'Ye present age distinguishes itself by adopting the most Elegant ornaments of the most refined Grecian artists, I am satisfy'd in conforming thereto, and humbly copying their style, and making new combinations of old ornaments'.

The early part of the nineteenth century marks the golden age of wine labels (pl 19); there was a marked increase in the size and weight of all tableware. Rundell and Bridge, Royal Goldsmiths from 1804, became an important influence in the Regency revival of the silver business; to supply their clients with the most up-to-date plate, they were associated with some of the most acclaimed silversmiths of the day, such as Paul Storr, Benjamin Smith and Digby Scott, calling also on the services of well known fine artists and designers; pl 67 shows a design

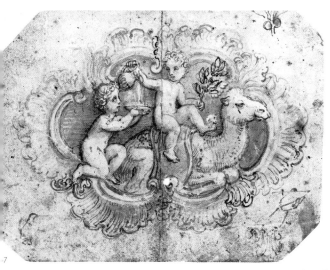

by Thomas Stothard (1755-1834), the painter and book illustrator who worked for Rundell's. Other firms producing wine labels at this time include Reily and Storer, Emes and Barnard, Rawlings and Summers, John E Terrey & Co. (all four being manufacturers to the trade), Edward Farrell (working mainly for the retailer Kensington Lewis) and R and S Garrard, and Hunt and Roskell, who were both retailers and manufacturers.

Silversmiths were to be found in many towns outside London, but they tended to concentrate in the places which had Assay Offices. Labels are recorded from Chester, Exeter, Newcastle, and York, as well as Birmingham and Sheffield. The craftsmen in these cities developed characteristics of shape, design and lettering which often enable their work to be identified.

Ireland in particular developed a very distinctive style of label from the last quarter of the eighteenth century, with makers such as John Teare and son, James Sherwin and Benjamin Taitt.

In Scotland although manufacturing was concentrated in Edinburgh and Glasgow, some provincial makers had labels assayed in their nearest cities, principally Aberdeen, Dundee, Inverness and Perth, and makers, confusingly, are also associated with other towns and cities. In Edinburgh James McKay, George McHattie and Robert Gray were notable, the latter producing engraved work of outstanding quality.

Further reading

Books

M. McKendry 'Seven Hundred Years of English Cooking' 1983 ed.

F. Bradbury: 'A History of Old Sheffield Plate' Sheffield 1968

E. Burton: 'The Georgians at Home' 1967

J. Culme: 'Nineteenth Century Silver' 1977

M. Clayton: 'The Collector's Dictionary of the Silver and Gold of Great Britain and North America' 1985 ed.

H.C. Dent: 'Wine, Spirit and Sauce Labels of the 18th and 19th centuries' H. W. Hunt, Norwich 1933

Goldsmiths' Hall: 'The Goldsmith and the Grape' 1983

A. Gruber: 'Silverware' New York 1982

A. Grimwade: 'London Goldsmiths 1697-1837' 1982 ed.

N.M. Penzer: 'The Book of the Wine Label' 1947

E.W. Whitworth: 'Wine Labels' 1966

H. Warner Allen: 'A History of Wine' 1961

Articles

Journal of the Wine Label Circle, April 1952 to the present day

I. Pickford: 'Wine Labels' Antique Collector April 1977

J. Culme: 'Beauty and the Beast: Power in the Silver Industry' Connoisseur February 1977

J. Banister: 'Wine and Spirit Labels in Harvey's Wine Museum' Antiques August 1977

J. Salter: 'Discovering Silver Condiment Labels' Country Life 30 September 1976

N.M. Penzer: 'Wine Labels at Buckingham Palace and Windsor' Connoisseur 1961

Important Collections (not necessarily open to the public)

Museum of London: The M.V. Brown Collection

The City Museum, Weston Park, Sheffield

New York Historical Society: The Weed Collection

John Harvey and Sons Museum of Bristol

The Ashmolean Museum Oxford: Mrs. M. Marshall Collection

The Worshipful Company of Goldsmiths

The Worshipful Company of Vintners: Anderson Collection

The Royal Collection